Rembrandt

A THOMAS NELSON BOOK

First published in 1993 by Thomas Nelson Publishers,
Nashville, Tennessee.

Copyright © 1993 by Magnolia Editions Limited

10 9 8 7 6 5 4 3 2 1

Library of Congress Cataloguing in Publication Data is available.

Library of Congress Card
93-83506

ISBN 0-7852-8307-2

MINIATURE ART MASTERS
GREAT EUROPEAN ARTISTS: REMBRANDT
was prepared and produced by
Magnolia Editions Limited,
15 West 26th Street, New York, N.Y. 10010

Editor: Sharyn Rosart
Art Director: Jeff Batzli
Designer: Susan Livingston
Photography Editor: Ede Rothaus

Printed in Hong Kong and bound in China

Rembrandt

Gerhard Gruitrooy

NELSON REGENCY
A Division of Thomas Nelson, Inc.

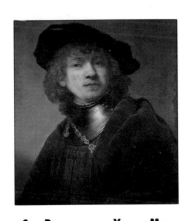

Self Portrait as a Young Man

CIRCA 1633; OIL ON CANVAS;
24″ × 20 ½″ (61 × 52 CM);
UFFIZI, FLORENCE

INTRODUCTION

Rembrandt Harmenszoon van Rijn, generally considered the greatest master of the Dutch school, was born in Leiden in 1609. Son of a miller, he studied for a short time at the University of Leiden before he was apprenticed to a local painter. The most influential training, however, he received under Peter Lastman in Amsterdam, where he spent about six months. After his return to Leiden in 1625, Rembrandt soon became a successful portraitist. His early works show a great interest in light effects and frequently represent scholars posed in lofty rooms or are studies of old age.

Around 1631 Rembrandt settled in Amsterdam where his *Anatomy Lesson of Dr. Tulp,* an unconventional approach to a traditional subject, made him

immediately famous. Many commissions followed, and in 1634 he married the wealthy Saskia van Uylenburgh, who provided him with money and connections. The next years were a period of happiness and opulence, best documented in the painting of *The Artist and his Wife Saskia.* There are also many portraits of Saskia alone, in paintings, etchings, and drawings. She died unexpectedly in 1642, leaving behind a son, Titus. That same year Rembrandt finished *The Company of Captain Frans Banning Cocq,* called *The Nightwatch* until 1947, when cleaning revealed that the scene had a daylight setting. Some biographers claimed that the painting was not well received and marked the beginning of Rembrandt's economic decline. What is certain is that Rembrandt faced bankruptcy in 1656 when his art collection and other property was sold at auction. To protect him from

creditors, his longtime companion Hendrikje Stoffels and Rembrandt's son, Titus, formed a business partnership to shield his earnings.

Despite his financial troubles, Rembrandt continued to receive commissions, and in his later years, painted a number of psychological portraits of deepened spirituality, including a series of self portraits and in 1662, the group portrait *Syndics of the Cloth Guild.* The flamboyance characteristic of Rembrandt's earlier works had matured into a deep insight into the human psyche and his late paintings are works of intense emotion. Tragically, he died in poverty in 1669, having outlived both Hendrikje and Titus. Rembrandt's vast output numbered more than 600 paintings and numerous sketches and drawings. He had a large school of followers, and the authorship of many works is still debated or reattributed to him.

An Old Man in a Military Costume

CIRCA 1630; OIL ON WOOD;
25 ½" × 20" (66 × 50.8 CM);
THE J. PAUL GETTY MUSEUM,
MALIBU, CALIFORNIA

Rembrandt was interested in generating particular light effects; in this work he used the metal piece from a suit of armor to depict reflections of luminescence. The man, who appears in a number of the artist's paintings and compositions, wears a mustache and stubbly beard. The wrinkled skin and the intense expression of his eyes are not necessarily flattering features, but they contribute to the work's individuality and dry charm. The enormous feather held onto the hat by a metal chain helps to fill the void around the sitter.

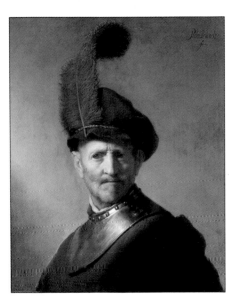

St. Paul in Contemplation

CIRCA 1629–1630; OIL ON CANVAS;
18 ½" × 15 ¼" (47 × 39 CM);
GERMANISCHES NATIONALMUSEUM,
NUREMBERG

The apostle is shown in a pensive mood before a table with an open book, probably a Bible. In his lowered right hand he is holding a quill, while the other hand rests on the surface of the table. The bearded face of the old man has been described as a portrait of Rembrandt's father, but this remains difficult to prove. The scene is illuminated by an invisible light source, most likely a candle, behind the book.

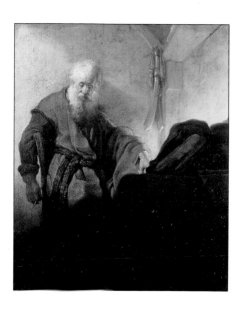

HOLY FAMILY

CIRCA 1633; OIL ON CANVAS;
72 ¼" × 48 ½" (183.5 × 123CM);
ALTE PINAKOTHEK, MUNICH

This humanized and charming rendering of a traditional subject, which might have been influenced by Rubens, allows the viewer to witness a highly personal event in a family's life. The child has fallen asleep after having been breastfed by his mother. Joseph, the proud father, bends over to watch his son. The cradle in which the child is soon to be placed is brightly lit. Some carpenter's tools on the wall in the background refer to Joseph's profession.

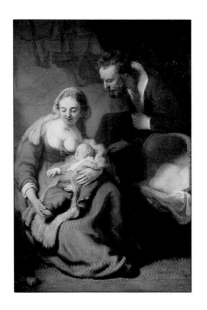

A PHILOSOPHER IN MEDITATION

1632; OIL ON WOOD;
11″ × 13 ½″ (29.9 × 34.3 CM);
LOUVRE, PARIS

The most prominent element in this painting is the wooden spiral staircase that envelops the space in which the philosopher is seated at a desk near an open window. A bright light is falling in from outside. A woman in the right foreground is attending to a fire, apparently to prepare a meal. This interior was probably inspired by one Rembrandt had seen in his own country.

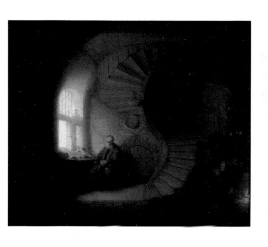

THE ANATOMY LESSON OF DR. TULP

1632; OIL ON CANVAS;
67" × 85 ½" (170 × 217 CM);
MAURITSHUIS, THE HAGUE

Medical scholars and students had only a rare
chance to assist dissections of a cadaver because
they were permitted only once a year, frequently
using the body of a victim of the death penalty. The
first professor to hold the chair of anatomy at the
university at Amsterdam was Dr. Nicolaes Tulp, who
in this painting is demonstrating to surgeons the
physiology of the arm and the muscles that move
the fingers. The names of the assisters have been
recorded in the sketchbook held by the man just
behind Dr. Tulp. Although the artist was quite precise
in his rendering of the body, it is unlikely that
Rembrandt attended any actual anatomic sessions.

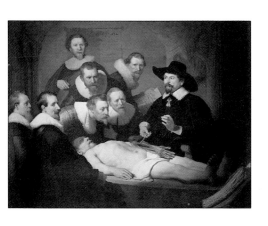

MALE PORTRAIT

CIRCA 1633; OIL ON WOOD;
35 ½" × 27 ¼" (90 × 69 CM);
KUNSTHISTORISCHES MUSEUM, VIENNA

The portrait of this anonymous sitter forms a pair
with the following one. They were obviously
meant to be hung in a way so that the couple,
husband and wife, would be facing each other.
Brought into relief by the monochrome, neutral
background, the man's head is turned full face to
the picture as he gazes gently at the viewer. His
body is shown in profile. He is sitting on a chair
only barely indicated behind his back. His right
hand makes a gesture toward the woman in the
companion picture.

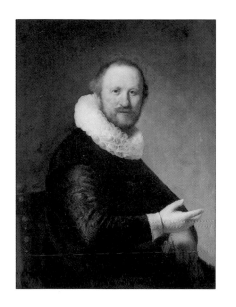

FEMALE PORTRAIT
CIRCA 1633; OIL ON WOOD;
35 ½" × 26 ½" (90 × 67.5 CM);
KUNSTHISTORISCHES MUSEUM, VIENNA

The companion piece to the previous painting, this portrait depicts a woman with gloves in her hands. Rendered in a three-quarter position, her eyes are directed toward her husband. Her outfit is more ostentatious than his, and includes a bracelet, lace cuffs, and a starched white bonnet. On her right index finger she wears a jeweled ring, probably that of her marriage. The couple were probably among the wealthy burghers of Amsterdam.

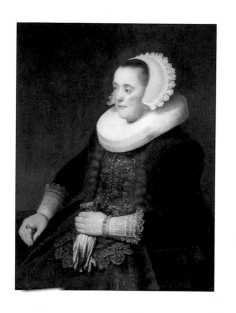

A Lady and Gentleman in Black

1633; Oil on canvas;
51 ³/₄″ × 43″ (131.4 × 109.2 cm);
Isabella Stewart Gardner Museum,
Boston

This double portrait of a husband and wife, probably rich burghers, was commissioned at a time when Rembrandt was enjoying great success. The unidentified sitters are shown in the front hall of their house. A wooden flight of steps in the back leads into the interior. The artist subtly interpreted the two different states of mind of the sitters, the woman staring pensively into the void, the husband looking boldly right out of the picture. The light falling across the room accentuates the ruff and the fine embroidery of the woman's dress.

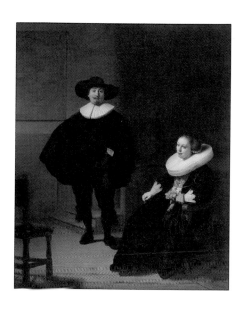

THE STORM ON THE SEA OF GALILEE

1633; OIL ON CANVAS; 63 5/8" × 51 1/8"
(161.7 × 129.9 CM); ISABELLA STEWART
GARDNER MUSEUM, BOSTON

According to the Gospels, Christ was asleep when a
storm broke out on the Sea of Galilee and threatened
to crush the boat in which he and the Disciples were
sailing. Christ calmed the waves and saved the com-
pany. Rembrandt depicted the moment of greatest
crisis, with some boatmen lowering the sails and
some speaking to Christ, while others—including
the one closest to the viewer who has become sea-
sick—are shown in various attitudes of fear and
confusion. The white foam is highlighted by the sun-
light breaking through the clouds. Christ appears as
the calm center of the turbulent scene, almost press-
ing the boat down with his physical presence.

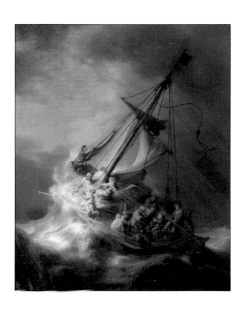

DEPOSITION

1634; OIL ON CANVAS;
62 ¼" × 46" (158 × 117CM);
HERMITAGE, ST. PETERSBURG

In this striking scene, the weight of Christ's body can be perceived from the men's struggles to lower him down from the cross. Among the crowd on the right is Mary, Christ's mother, shown at the moment of her greatest suffering. In the foreground on the left a precious fabric intended to receive the corpse is being spread out. The man in a turban seen from the back seems to be Nicodemus, who bought Christ's body from Pilatus in order to assure a proper burial. The nighttime scene is lit by a single candle carried by the boy on the ladder. He is protecting our eyes from the bright flame with his hat.

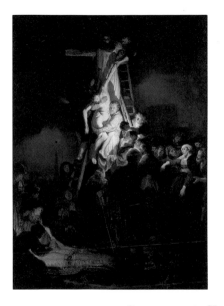

ARTEMISIA
1634; OIL ON CANVAS;
56" × 60 ¼" (142 × 153 CM);
PRADO, MADRID

At the age of 28, Rembrandt married Saskia van Uylenburgh, the daughter of an Amsterdam antiques dealer. The artist's young wife might have served as the model for this painting. The richness of the figure is underlined by the ornate dress and the seashell cup presented by the servant. Whether the figure indeed represents Artemisia receiving the ashes of her husband Mausolus, or Sophonisba, who was sent a cup of poison after her husband's death in the Roman conquest of Carthage, cannot be determined with certainty. Both cases were considered examples of conjugal love.

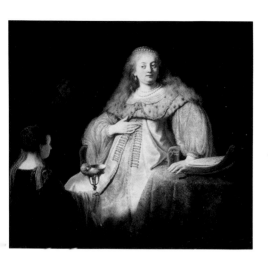

DANAË

1636; OIL ON CANVAS;
72 ¾" × 80" (185 × 203 CM);
HERMITAGE, ST. PETERSBURG

Fearing the prophecy that he would be killed by a son of his daughter Danaë, Acrisius, King of Argos, decided to imprison her in a room in a tower. Zeus, disguised as a shower of gold, nevertheless succeeded in visiting the young woman. Eventually, Danaë gave birth to Perseus and the oracle was fulfilled. Instead of depicting tangible gold coins as was customary in previous paintings of this subject, Rembrandt used gold-colored light to represent the mysterious visitor. Danaë, lying stretched out on a sumptuous bed, appears to welcome Zeus, while an old guardian woman carrying keys over her arm raises the curtain to let him in.

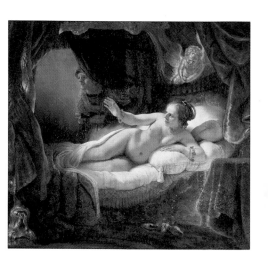

THE RAPE OF GANYMEDE

1635; OIL ON CANVAS;
67 1/4" × 51 1/4" (171 × 130 CM);
STAATLICHE KUNSTSAMMLUNGEN,
ALTE MEISTER, DRESDEN

One of Rembrandt's most unusual paintings, this work illustrates the classical myth of the abduction of the beautiful child Ganymede by Zeus disguised as an eagle. He carried the boy up to the Olympus to serve the gods at their table. Contrary to tradition, the rape is shown in all its consequences. The boy grimaces and cries out in pain and terror under the bird's sharp grip. His tasseled nightshirt is contemporary and adds a unique element to the painting.

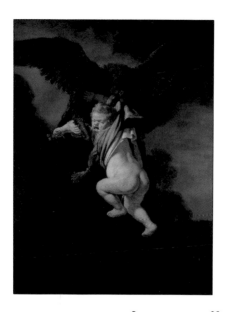

R E M B R A N D T **33**

SASKIA AS FLORA

1635; OIL ON CANVAS;
48 ⅝" × 38 ⅜" (123.6 × 97.5 CM);
NATIONAL GALLERY, LONDON

The woman is believed to be Rembrandt's wife,
Saskia, who was married to the artist on July 22,
1634. She appears in an Arcadian costume hold-
ing a staff and a bouquet of flowers in her hands,
and wearing a garland on her head. The fabric is
remarkably rich and the woman's hair falls in curly
waves down to her shoulders. She might actually
represent Flora, the Roman goddess of summer
and fertility. During Rembrandt's time, plays and
poems about shepherds and shepherdesses were
very popular and it was fashionable to appear at
parties in an Arcadian dress.

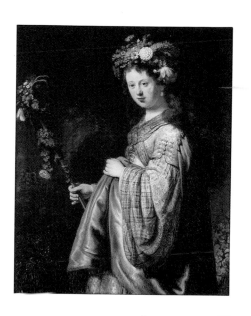

THE ARTIST AND HIS WIFE SASKIA

1635–1636; OIL ON CANVAS;
63 ½" × 51 ½" (161 × 131CM);
STAATLICHE KUNSTSAMMLUNGEN,
ALTE MEISTER, DRESDEN

The subject of this exuberant painting has also been identified as *The Prodigal Son in a Tavern,* but it might very well represent a happy moment in Rembrandt's life. The characteristic elongated glass is raised to propose a toast. The man has his head turned around and the woman on his lap is also looking back over her shoulder, including the viewer in the celebration. The ornate dresses and the peacock pie, an expensive dish, indicate that this is a special moment. Originally, the painting extended further to the left and must have included a larger still life.

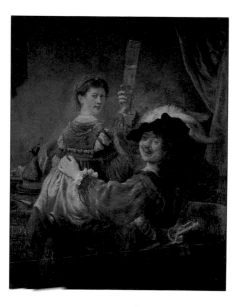

ASCENSION OF CHRIST

1636; OIL ON CANVAS;
36 ½" x 26 ⅞" (92.7 x 68.3 CM); ALTE
PINAKOTHEK, MUNICH

Christ is standing on a cloud supported by *putti*, rising up to heaven. His arms are stretched out and His eyes are directed upward. Bright, golden light, which is reflected by some of the apostles who stand below witnessing the event, is floating down from heaven to create a mystical atmosphere. The painting is part of a series executed for the Stadtholder Frederick Henry of scenes from the life of Christ. The delivery of the pictures was somewhat delayed, resulting in a lively correspondence between Rembrandt and the Stadtholder's secretary. These letters are the only documents in the artist's handwriting in existence.

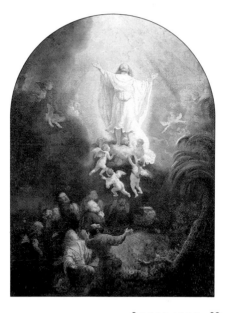

Susanna and the Elders

1637?; Oil on canvas;
18 ³/₄" × 15 ¼" (47.5 × 39 cm);
Mauritshuis, The Hague

The story is taken from the Book of Daniel. Susanna, accused of adultery by two elderly men whose advances she had rejected, was sentenced to death. Her life was spared through the intervention of the prophet Daniel, who revealed the men's wrongdoing. Here Susanna has just prepared to take her bath. The woman has turned her head to look out of the picture with an expression of fear and surprise upon hearing some noise in the bush behind her. Rembrandt focuses on the moment the chaste woman hastily tries to cover her body. Even the viewer feels like an intruder into her privacy.

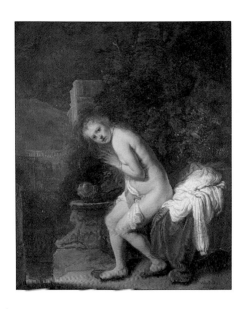

SACRIFICE OF ISAAC
1635; OIL ON CANVAS;
76" x 52 ¼" (193 x 133 cm);
HERMITAGE, ST. PETERSBURG

This painting, full of drama, movement, and emotion, illustrates a scene from the Old Testament. Abraham, following the Lord's command, is ready to sacrifice his own son, Isaac, but a voice from heaven stops him because he has proved his obedience. Rembrandt introduced into the scene an angel who restrains Abraham by seizing his wrist so that the sacrificial knife falls to the ground. Light shines fully on the boy, whose head has been pushed back by his father's arm, thereby exposing his throat. The artist's fascination with light effects was influenced by paintings in the style of Caravaggio.

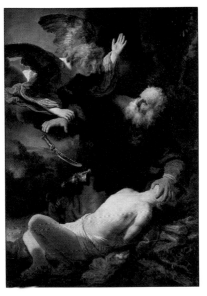

SAMSON THREATENING HIS FATHER-IN-LAW

1635; OIL ON CANVAS;
62 ½" × 51 ½" (158.5 × 130.5 CM);
GEMÄLDEGALERIE, STAATLICHE MUSEEN
PREUSSISCHER KULTURBESITZ, BERLIN

This is another biblical scene, in which a self-confident Samson has angrily raised his fist against his father-in-law who, peeking carefully out of a window, denies him access to the house. A sword dangles from the young man's belt and his long curly hair, the secret source of his great physical strength, frames his face. His threatening gesture is heightened by the frightening look in his eyes. The powerful immediacy of the scene is now even more obvious since the painting has been slightly cut down on the left.

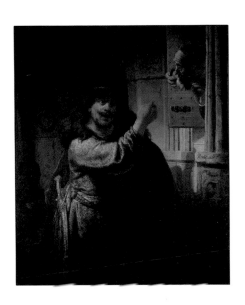

PARABLE OF THE LABORERS IN THE VINEYARD
1637; OIL ON WOOD;
12 ¼" × 16 ½" (31 × 42 CM);
HERMITAGE, ST. PETERSBURG

Signed and dated by the artist, this painting is executed in warm browns and greens and has almost the character of a drawing. The figures blend into the detailed setting of the interior in a complex pattern of overlapping forms. The center of the semicircular composition is left void except for the realistic depiction of a playful cat on the steps in the foreground. The room is reminiscent of the one in *A Philosopher in Meditation* (see page 14).

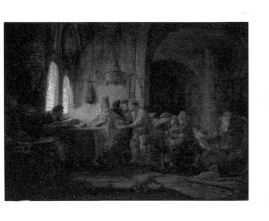

SAMSON POSING A RIDDLE AT THE WEDDING FEAST

1638; OIL ON CANVAS;
49 ¾" × 69" (126.5 × 175.5 CM);
STAATLICHE KUNSTSAMMLUNGEN,
ALTE MEISTER, DRESDEN

Samson, an Israelite, married a woman from the enemy camp, a Philistine. This painting shows the moment during the wedding feast that he set his guests a riddle: "Out of the eater came forth meat, and out of the strong came forth sweetness." Samson, sitting to the right of the table, uses rhetorical gestures to add force to his words. The riddle referred to the lion Samson had killed with his own hands, and in whose body he later found a honeycomb. He had told only his wife the answer, but she betrayed him by telling the story to her countrymen. Angered, Samson slew thirty of the Philistines.

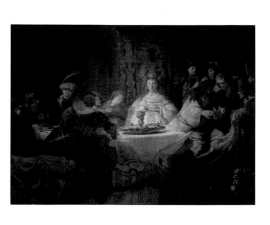

THE ARTIST'S MOTHER AS PROPHETESS HANNAH

1639; OIL ON OAK;
31 ½" × 24 ¼" (79.5 × 61.7CM);
KUNSTHISTORISCHES MUSEUM, VIENNA

Traditionally, the woman in the painting is identified as Rembrandt's mother. This is the last rendering of her likeness and the only one from the artist's Amsterdam period. The woman's wrinkled face is covered with a prayer shawl and her hands are resting on a stick. The fur-lined coat is held together by a golden brooch. As is often the case in Rembrandt's oeuvre there is no clear distinction between a portrait and historical or religious subject matter. Prophetess or the artist's mother, the old woman is posed to express dignity and self-respect.

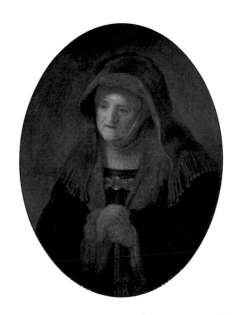

THE COMPANY OF CAPTAIN FRANS BANNING COCQ AND LIEUTENANT WILLEM VAN RUYTENBURGH ("THE NIGHTWATCH")

1642; OIL ON CANVAS; 143" × 172"
(363 × 437CM); RIJKSMUSEUM, AMSTERDAM

Arguably Rembrandt's most famous painting, this scene depicts the advance of the militia company of Captain Frans Banning Cocq and Lieutenant Willem van Ruytenburgh. For more than a century, it was erroneously known as *The Nightwatch* due to the darkened varnish. The scene is full of action and movement. On the left a man charges a musket with powder, while behind him the mascot, a little girl in a yellow dress, carries the company's silver drinking horn. From her belt hangs a chicken, a pun on the group's coat of arms, which includes two bird's talons.

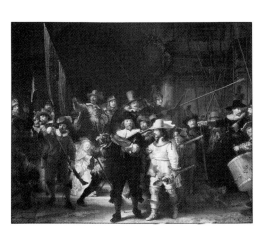

CASTLE AT TWILIGHT

CIRCA 1643; OIL ON WOOD;
17 1/4" × 23 1/2" (44 × 60 CM);
LOUVRE, PARIS

Formerly in the Stroganoff collection in St. Petersburg, this work entered the Louvre as late as 1948. It is one of the rare landscape paintings by the artist. A castle-like structure on a hilltop is set against the twilight of the sky. A river in the foreground separates us from the building, which does not seem to offer an entrance. Rembrandt was obviously not interested in depicting architecture per se, but rather its atmosphere under specific conditions of light.

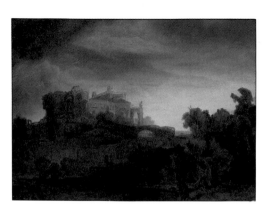

THE SUPPER AT EMMAUS

1648; OIL ON WOOD;
26 ³/₄" × 25 ¹/₂" (68 × 65 CM);
LOUVRE, PARIS

In this biblical story, during a pilgrimage to Emmaus two of Christ's disciples encountered their master after His resurrection. They recognize Him only after reaching the inn where He blesses and breaks the bread for their common meal. In the painting, light emanates from Christ, whose figure is framed by a tall niche behind Him. His eyes are raised ecstatically upward in prayer. The two apostles' emotional confusion is contrasted with the expressionless face of the young servant, who is unaware of the event. The figure of Christ has been compared to the one in da Vinci's famous fresco of the *Last Supper* in Milan, which Rembrandt knew only through engravings.

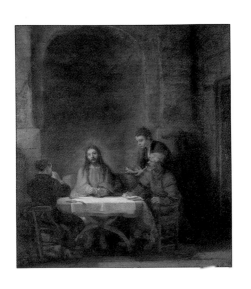

Christ Teaching ("The Hundred Guilder Print")
CIRCA 1648–1650; ETCHING;
11" × 15 ½" (28 × 39.6 CM);
BIBLIOTHÈQUE NATIONALE, PARIS

Turning away from the more violent biblical subjects of the 1630s, here Rembrandt combined several gentler scenes from the Gospel after St. Matthew: the healing of the sick, Christ's challenge by the Pharisees, the children coming to Him, and, to the right, where a camel appears, the image of the parable of the camel that shall go through the eye of a needle more easily than a rich man shall enter the kingdom of heaven. Tradition has it that Rembrandt bought back a print of his own etching at auction for the exceptional price of 100 guilders, possibly to enhance the value of his other works.

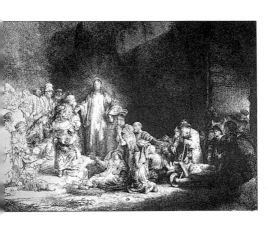

ARISTOTLE WITH THE BUST OF HOMER

1653; OIL ON CANVAS;
56 ½" × 53 ¾" (143.5 × 136.5 CM);
METROPOLITAN MUSEUM OF ART, NEW YORK

Although he never left his native country,
Rembrandt had a reputation that reached even
a patron in Sicily, who commissioned this paint-
ing for his library, where it was to join a series
of portraits of famous men. Rembrandt was
undoubtedly familiar with Aristotle's philosophy
from his days at school. Resting his right hand
on a bust of his blind teacher, Homer, Aristotle
stands before us with a contemplative gaze. A
heavy gold chain painted in thick impasto holds a
medallion with the likeness of Aristotle's pupil
Alexander the Great, to whom he had taught the
art of war using quotations from Homer.

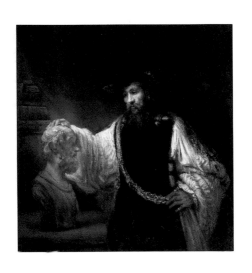

PORTRAIT OF HENDRIKJE STOFFELS

CIRCA 1654; OIL ON CANVAS;
29 $\frac{1}{4}$" × 24" (74 × 61 CM);
LOUVRE, PARIS

Informally but elegantly dressed in a fur coat, the woman in the painting is wearing precious earrings with large pearls as well as a brooch and bracelets. Red ribbons hold up her elaborate coiffure. Her facial expression is lacking all signs of emotion except for her large glowing eyes, which look out of the picture with a certain melancholy. The sitter is generally thought to be Rembrandt's companion Hendrickje Stoffels, who joined the artist's household in 1649. In 1654 she bore him a daughter.

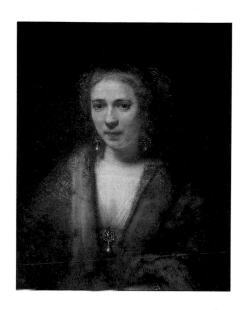

BATHSHEBA

1654; OIL ON CANVAS;
56" × 56" (142 × 142 CM);
LOUVRE, PARIS

In this painting, Rembrandt depicted the moment when Bathsheba pondered her dilemma: Should she obey the king or stay faithful to her husband, Uriah? King David had watched the woman at her bath and decided to send her a message. Here, Bathsheba is holding the paper face down while the serving woman is drying her feet with a cloth. The viewer's attention is drawn to Bathsheba's slightly bent head and the troubled expression on her face. Avoiding anecdotal detail, Rembrandt focuses on the psychological aspect of the story.

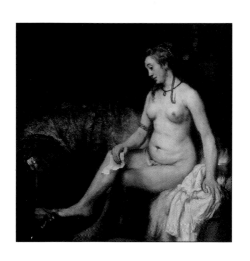

THE CARCASS OF BEEF

1655; OIL ON WOOD;
37" × 27 ⅛" (94 × 69 CM);
LOUVRE, PARIS

To the modern beholder the subject of this painting might appear repulsive or even ugly. For Rembrandt and his contemporaries, however, it must have been a normal and frequently observed phenomenon of daily life. The room in which the carcass is hung is shown at an angle, emphasizing the visual effect of the enormous cadaver. In the back a woman looks out of a door. The painting inspired a number of artists, among them Delacroix, Daumier, and Soutine, who either made copies of it or reinterpreted the subject.

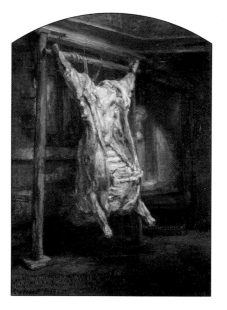

SELF PORTRAIT IN A FUR COAT

1655; OIL ON OAK;
26" × 20 ⅞" (66 × 53 CM);
KUNSTHISTORISCHES MUSEUM, VIENNA

Rembrandt recorded his own likeness many times throughout his career (see pages 4 and 90). Here the noble, but somewhat tired looking face of an almost 50-year-old man gazes out of the painting. He is wearing a fur coat, an earring, and a golden chain even though he was in serious financial difficulty at the time of this painting. In the following year he declared bankruptcy and was forced to sell the inventory of his studio. An itemized list drawn up for the occasion provides us with detailed information about his belongings, particularly about the studio props that were used in his paintings.

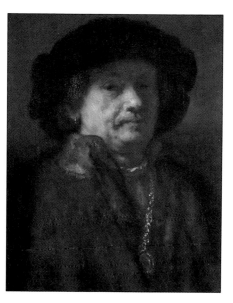

THE ARTIST'S SON TITUS READING

1656–1657; OIL ON CANVAS;
27 ¾" × 25 ¼" (70.5 × 64 CM);
KUNSTHISTORISCHES MUSEUM, VIENNA

Born in 1641, Titus was Rembrandt and Saskia's only child to survive infancy. Here he is seen as an adolescent, seated, reading a book, his gently smiling face illuminated by a soft light. His hat is not unlike the one Rembrandt used in his early self portrait (see page 4). Titus was a favorite portrait subject for Rembrandt. He later saved his father from destitution when he formed a company to protect Rembrandt from his creditors by officially employing him and selling his paintings. Another tragedy in the painter's life was Titus' untimely death in 1668, about six months after his marriage.

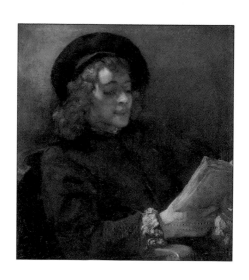

David Playing the Harp before Saul

1657; OIL ON CANVAS;
51 ½" × 64 ½" (131 × 164 CM);
MAURITSHUIS, THE HAGUE

In this painting, a melancholy King Saul is seeking consolation in the music made by the young David, who is playing the harp. He is apparently moved by the music as he is wiping a tear from his eye with a dark curtain. At the same time, however, Saul's uncovered eye betrays his sinister feelings for David, whose popularity is beginning to overshadow Saul's own fame. His right hand is about to grasp the lance that he will hurl at his rival. Shades of black and the heavy brocade and jewelry contribute to the gloomy atmosphere of the picture, which reveals a deep psychological insight into the king's inner conflict.

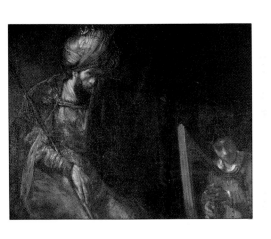

A Young Woman Trying on Earrings

1657; Oil on wood;
15 ½" × 12 ¾" (39.5 × 32.5 cm);
Hermitage, St. Petersburg

This painting shows a young woman, sometimes considered to be a courtesan, sitting before a mirror trying on an earring with a large pearl. The carefully observed pose appears to be studied from life and is rendered with a touching tenderness. The woman's eyes are turned toward the image in the mirror as she smiles with satisfaction. The palms of her hands serve as a backdrop for the precious jewel. The movement of her arms and the inclined head provide the picture with natural movement.

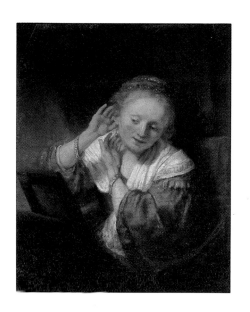

Two Negroes

1661; OIL ON CANVAS;
30 ½" × 25 ¼" (77.8 × 64.4 CM);
MAURITSHUIS, THE HAGUE

A tireless student of the expressions of human faces, Rembrandt dedicated much of his time to painting the characters he encountered in the streets of the cosmopolitan city of Amsterdam. While there are many portraits of old Jews, his depictions of black people are apparently rare. This work is a bust-length portrait of a young black man and his companion. Their pose is intimate, with the companion's head resting on the young man's shoulder. The men's characters are distinct; the first looks proudly outward, while the other is more introverted.

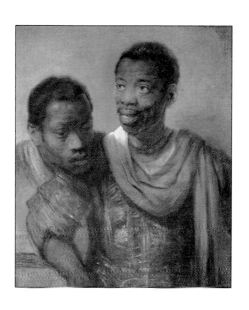

THE SYNDICS OF THE CLOTH GUILD
1661–1662; OIL ON CANVAS;
75 ½" x 110" (191.5 x 279 CM);
RIJKSMUSEUM, AMSTERDAM

In 1661 the six members of the cloth guild—
also called the *Staalmeesters* after the Staalhof,
where they held their sessions—asked
Rembrandt to paint a group portrait of them.
Their duty was to exercise quality control over
the fine cloths traded in Amsterdam. Trying to
avoid any repetition, Rembrandt arranged the
sitters around a table in various attitudes and
expressions. Since the painting would be hung
high, he preferred to paint them from below. The
rug on the table is a typically Dutch tradition that
remains common today.

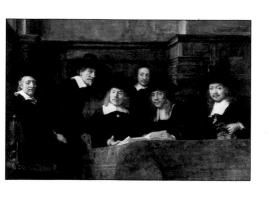

St. Matthew Inspired by an Angel

1661; OIL ON CANVAS;
37 $\frac{3}{4}$" × 31 $\frac{7}{8}$" (96 × 81 CM);
LOUVRE, PARIS

Rembrandt depicted a meditating St. Matthew who is writing the Gospel while a visiting angel dictates the words into his ears. Following a long-standing tradition the evangelist is unaware of the angel's presence. He appears thoughtful, his left hand raised to his bearded chin while his right is prepared to mark down the words with a writing utensil. Of particular technical interest is the challenging juxtaposition of a youthful angel with the weathered face of an old man.

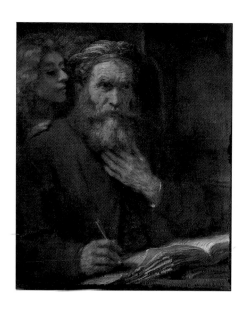

PORTRAIT OF JACOB TRIP

CIRCA 1661; OIL ON CANVAS,
51 ³⁄₈" × 38 ¼" (130.5 × 97CM);
NATIONAL GALLERY, LONDON

The merchant Jacob Trip was 87 years old when Rembrandt painted his likeness. He is dressed in an informal gown and a skull cap, the latter being popular at that time, particularly among scholars and artists. Jacob was the patriarch of a prominent and wealthy family whose businesses included iron mines, arms factories, and financial dealings. His brother and his three sons all lived and worked in Amsterdam, while Jacob remained in his native Dordrecht, a city near Rotterdam.

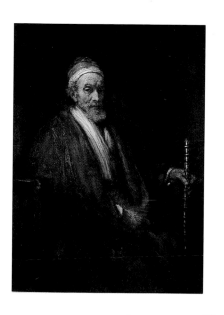

"THE JEWISH BRIDE"

CIRCA 1666; OIL ON CANVAS;
47 ¾" × 65 ½" (121.5 × 166.5 CM);
RIJKSMUSEUM, AMSTERDAM

This painting acquired its popular title as late as the nineteenth century, when the scene was interpreted as a Jewish father hanging a chain around his daughter on the occasion of her wedding. Today it is considered more likely that the man is her lover or husband and whether the couple is Jewish at all is doubtful. The caring and tender gestures convey an intimate and loving relationship. The thick paint, applied with a palette knife instead of a brush, gives texture to the material of the clothing and evokes the glitter of gold.

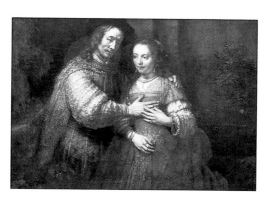

HOMER DICTATING TO A SCRIBE

1663; OIL ON CANVAS;
42 ½" × 32 ½" (108 × 82.4 CM);
MAURITSHUIS, THE HAGUE

Homer, the Greek poet who wrote the *Iliad* and the *Odyssey*, was reputed to have been blind, and Rembrandt depicted him according to tradition. Originally, the figure of Homer was accompanied by a pupil or scribe who took down his words, but a fire in the eighteenth century destroyed the right half of the canvas and its complete version is now known only through one of Rembrandt's drawings. With his right hand Homer is beating out the rhythm of the lines to follow a fixed meter while he dictates the text. Rembrandt used as his model a well-known Hellenistic bust of the poet that he had also used in an earlier painting (see page 60).

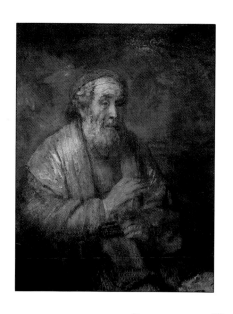

Return of the Prodigal Son

1668–1669; Oil on canvas;
103 ¹/₈" × 80 ⁵/₈" (262 × 205 cm);
Hermitage, St. Petersburg

This is one of Rembrandt's last and most profound paintings, which shows the higher spiritual awareness and psychological insight that prove the aging artist's great visual powers. The main group of the father and the Prodigal Son is singled out against a large dark surface highlighted by an external light source. Bald and in ragged clothes, the son returns home after wasting his inheritance in foreign lands. The old man comes to greet his long-lost son, welcoming him with the utmost fatherly love. The extraordinary solemnity of this monumental work is an extremely impressive evocation of human sympathy.

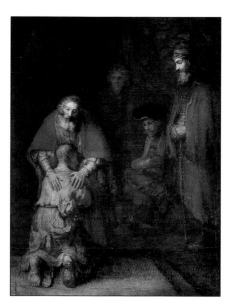

Self Portrait at Old Age

1669; Oil on canvas;
33 ⁷/₈" × 27 ³/₄" (86 × 70.5 cm);
National Gallery, London

A recent restoration of this work revealed that Rembrandt had originally painted his portrait as that of an artist holding a brush and a maulstick, but he must have changed his mind since the overpaint is clearly Rembrandt's own. Although the outward circumstances in the last years of his life were difficult, during that time his art gained in spiritual depth and power of expression. Rembrandt's moral strength might have protected him from being crushed by his terrible experiences. This is the last image of him before his death on October 4 of that same year.

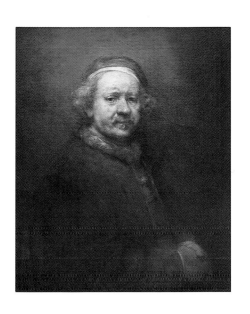

Elephant

1637; Black chalk, on white paper;
9 ¼" × 14" (23.3 × 35.4 cm);
Graphische Sammlung Albertina, Vienna

Rembrandt was not only an extraordinary painter, but also a highly gifted draughtsman and engraver (see page 58), and many of his works on paper have been preserved. Among the considerable number of animal studies executed over the years, elephants and lions are the most common subjects. In this drawing, the artist's mastery is not confined to depicting the external likeness of the animal alone. The heavy weight of the elephant's body is carried by the light, almost dancing, legs and the thick wrinkled skin shimmers with a silver-gray light. Rembrandt must have studied an elephant from life, probably at a traveling circus.

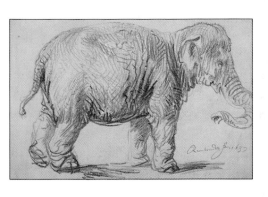

INDEX OF ARTWORKS

PHOTOGRAPHY CREDITS

Art Resource, New York pp. 19, 21, 23, 25, 51, 71, 79, 83, 85, 87

Collection of the J. Paul Getty Museum, Malibu, California p. 9

Giraudon/Art Resource, New York pp. 15, 59, 67

Erich Lessing/Art Resource, New York pp. 33, 37, 49, 55, 57, 63, 69, 73, 81, 91, 93

The Metropolitan Museum of Art. Purchased with special funds and gifts of friends of the Museum, 1961, p. 61

Scala/Art Resource, New York, front jacket, pp. 4, 11, 13, 27, 29, 31, 35, 39, 41, 43, 45, 47, 53, 65, 75, 77, 89